STEVE PARISH

DISCOVERING
Adelaide
SOUTH AUSTRALIA

A Little Australian Gift Book
www.steveparish.com.au

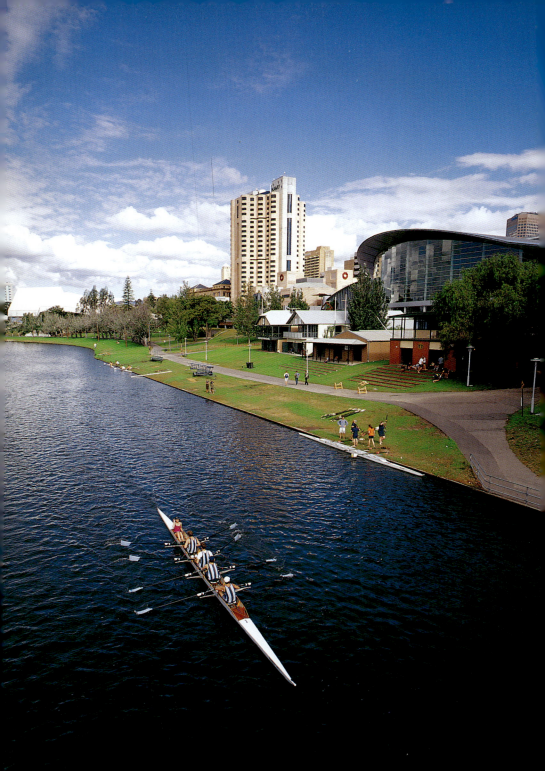

DISCOVERING ADELAIDE

Adelaide, capital city of South Australia, spreads across a narrow coastal plain on the shores of Gulf St Vincent. Backed by the tiered slopes of the Mt Lofty Ranges, the city enjoys a Mediterranean climate.

Since its beginnings as a free settlement in 1836, Adelaide has matured into a vibrant city renowned for its cultural and performing arts festivals. It also hosts a dynamic restaurant scene where European tradition and Australian creativity draw on a cornucopia of seafoods, hinterland produce and fine wines.

Adelaide's broad avenues, public squares, parklands and stately colonial buildings provide a delightful setting for this gracious southern city. A long stretch of safe, clean beaches and the peaceful green of the Adelaide Hills complete the picture of a city that takes pleasure in a relaxed, open lifestyle.

Gateway to the State

Beyond the villages of the Adelaide Hills lie the famous vineyards of McLaren Vale, and the Clare and Barossa Valleys. Further still is the rugged grandeur of sculpted coastlines and time-worn mountains, the subtlety of mallee wildflowers and riverland billabongs, and the vastness of salt lakes and northern sand plains.

South Australia and its Festival City embody a remarkable celebration of Australia's natural and cultural heritage.

Page 2:

Rowers training on the city reach of the River Torrens where it widens into Torrens Lake.

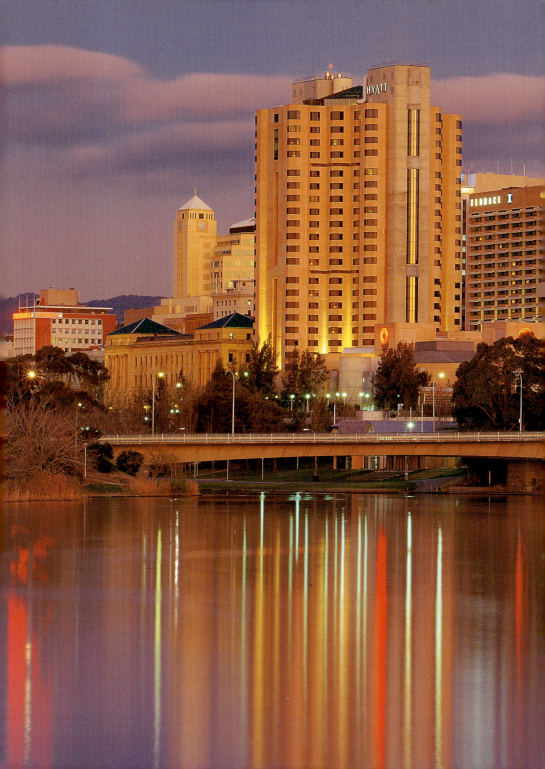

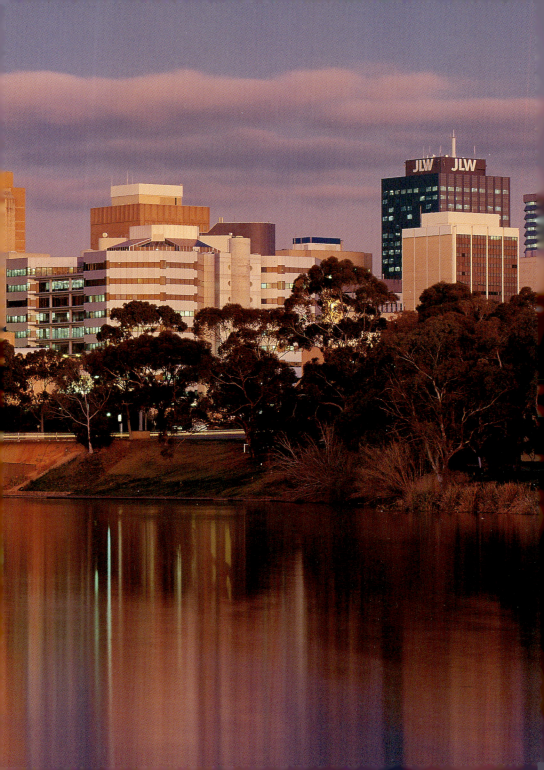

FESTIVAL CITY

Denizens of Adelaide enjoy a celebration, whether it's Proclamation Day, the Christmas Pageant, Adelaide Cup Carnival, the Festival of Arts or any number of local carnivals, festivals and fetes. The biennial Arts Festival, featuring over 500 performances, draws artists and audiences from around the world. The offbeat approach of the associated Fringe Festival has an equal following. The lakeside Festival Centre, with its broad plaza, theatres and concert hall, is a focal point for many of the city's musical and theatrical events.

Pages 4–5:
Torrens Lake was especially made on the Torrens River to enhance the city's beauty.

Right:
The Adelaide Festival Centre by Elder Park on Torrens Lake.

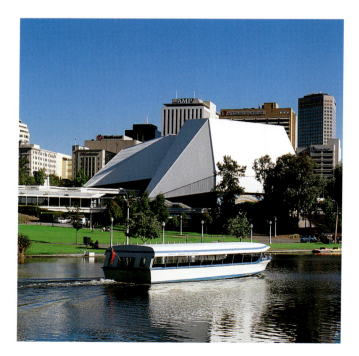

CASINO AND RAILWAY STATION

North Terrace is a shady boulevard of contrasts where colonial edifices oppose 20th-century shops and offices. But the two worlds meet behind the restored facade of the Railway Station. As Lady Luck tempts patrons in the elegant Adelaide Casino, arriving and departing trains below satisfy the need or whim to travel the city's surrounds.

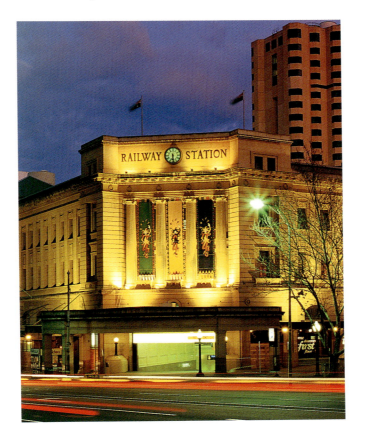

Left:

The Adelaide Casino and Railway Station on North Terrace.

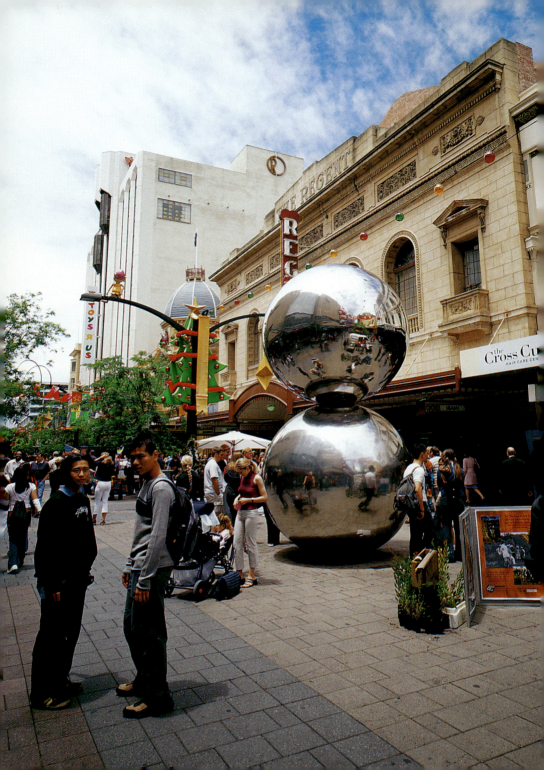

RUNDLE MALL

This paved avenue of sidewalk cafés, boutiques, arcades and cinemas is the heart of Adelaide's shopping precinct. A lively and colourful atmosphere fills the Mall as people stroll among fruit stalls, flower sellers and buskers. Shade trees, park benches and eye-catching sculptures invite the weary shopper to relax and enjoy the passing parade.

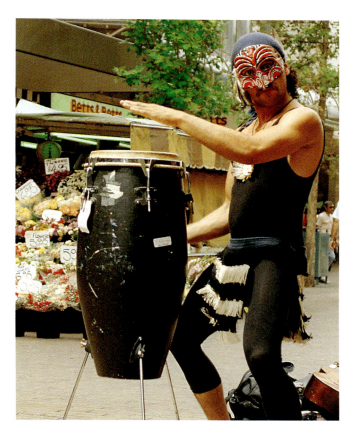

Page 8:

Bert Flugelman's silver spheres reflect the bustle of Rundle Mall.

Left:

Buskers entertain shoppers in the mall.

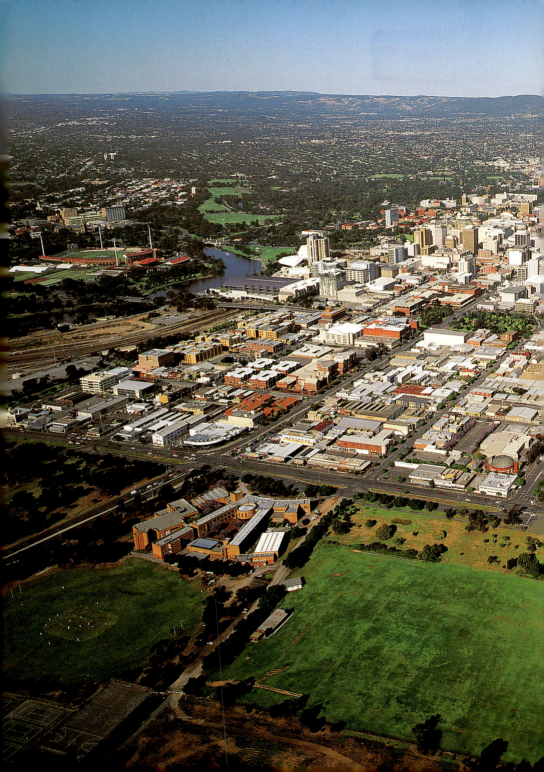

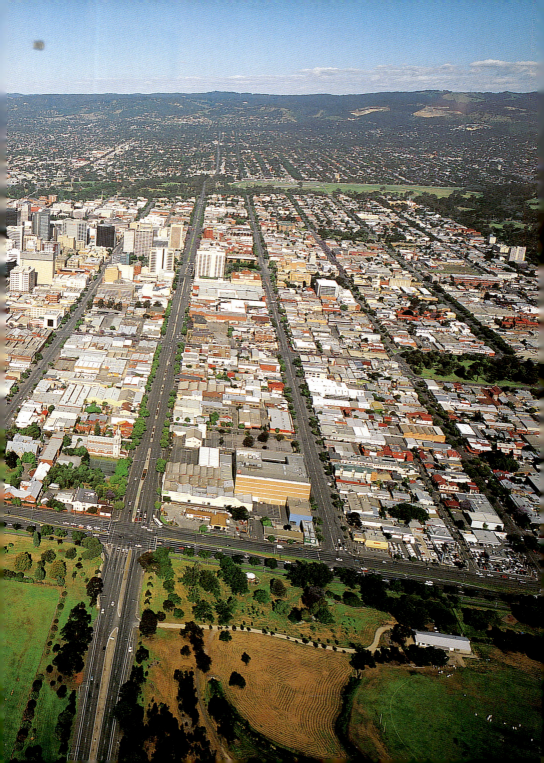

page twelve

LOOKING BACK

Adelaide takes pride in its architectural heritage. The grace and symmetry of its spired churches, public buildings and elegant homes give the city a unique charm. These fine examples of pointed bluestone and dressed sandstone are a tribute to the craftsmanship of colonial stonemasons.

Pages 10–11:
Aerial view of Adelaide, showing the regular grid pattern of the streets.

Right:
The view down Hindley Street.

Page 13:
Mitchell Building, Adelaide University, North Terrace.

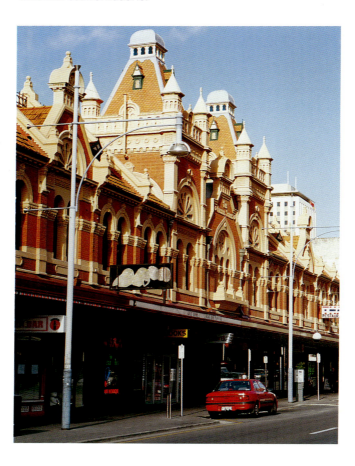

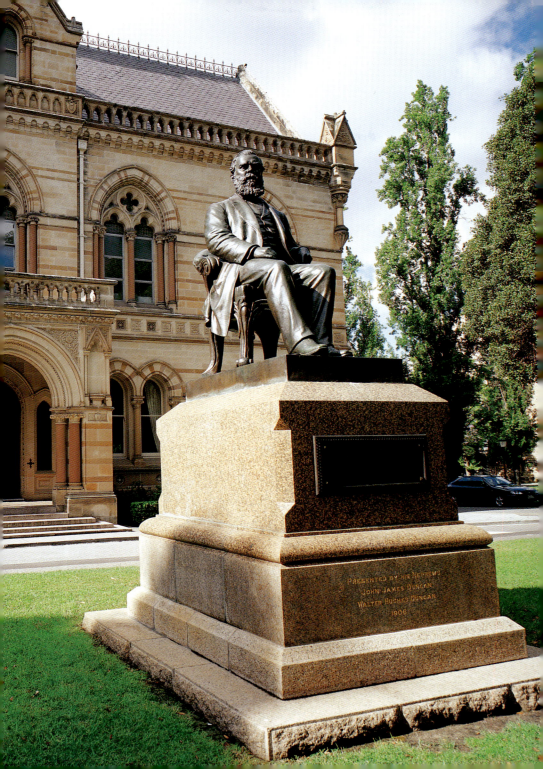

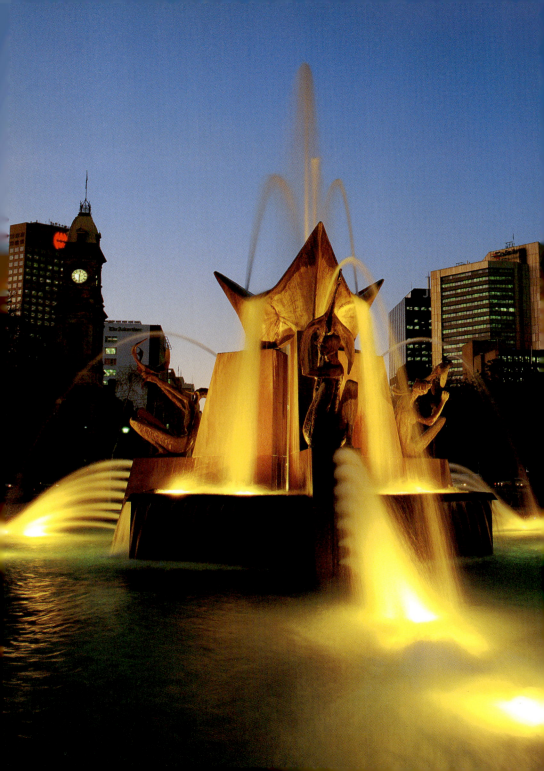

SPACIOUS CITY SQUARES

In 1836, Colonel William Light bequeathed Adelaide a stylish city centre designed for people. Extensive parklands surround its simple grid of wide thoroughfares anchored by five public squares. The Victoria Square fountain is one of many sculptural elements enhancing the city's open spaces.

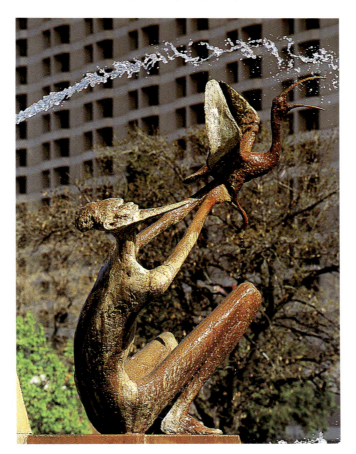

Page 14:
John Dowie's Victoria Square fountain symbolises Adelaide's rivers.

Left:
One of the fountain's river spirits.

ADELAIDE'S GARDENS

In 1837 Colonel Light's plan for Adelaide showed an area set aside for a botanic garden, but it was 1857 before the Botanic Garden and State Herbarium were officially opened at the present site. These gardens are an important part of the extensive parks and sporting fields that encircle the city. The beautiful Palm House, which was completely restored in 1994–95, was opened in 1877. The garden plays host to many educational and scientific displays of exotic and native ornamental plants, and the species grown range from palms and endangered cycads to herbs for cooking and medicine.

Right:
Looking through the main gates of the Botanic Garden to the Botanic Hotel.

Page 17:
A quiet path in the Botanic Garden of Adelaide.

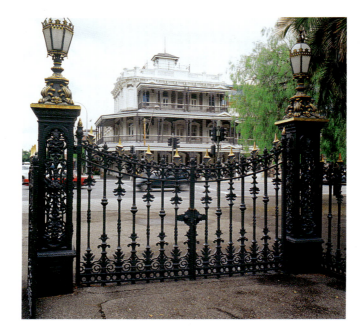

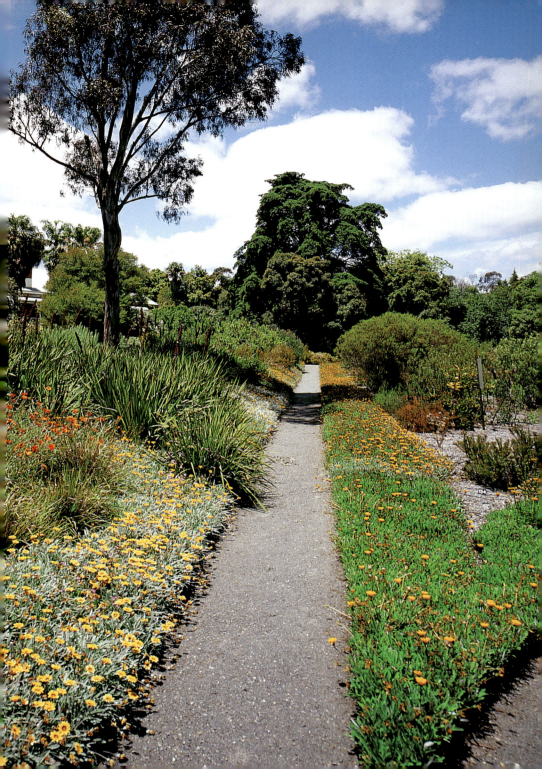

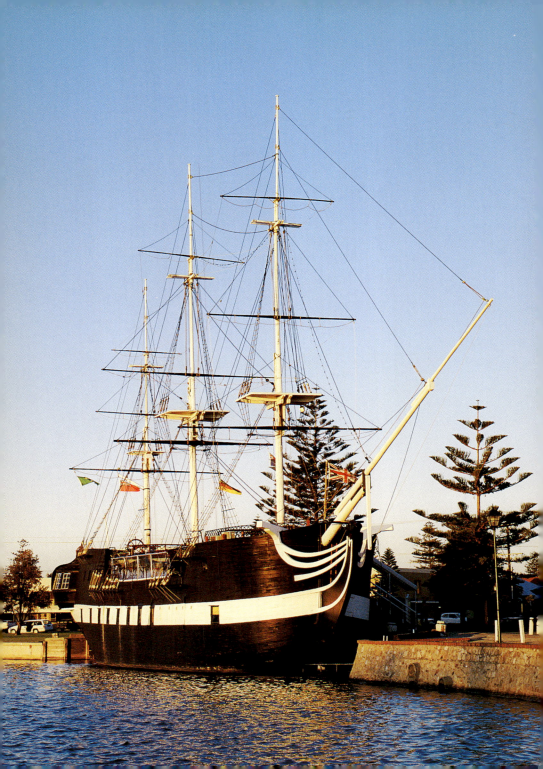

NAUTICAL HISTORY

A site for Adelaide was chosen by Colonel Light in 1836, in preference to alternatives at Kangaroo Island, Encounter Bay and Port Lincoln. Later that year, on 28 December, Captain John Hindmarsh, the first governor, arrived at Holdfast Bay aboard *HMS Buffalo* and proclaimed the Province of South Australia. Goods and passengers were loaded through the surf at Glenelg until facilities were established at Port Adelaide in 1838.

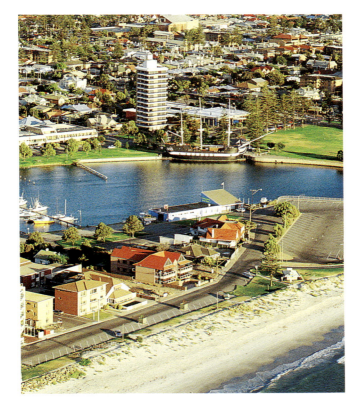

Page 18:
This replica of HMS Buffalo houses a museum and restaurant.

Left:
The HMS Buffalo replica is anchored at Patawalonga Boat Haven, Glenelg.

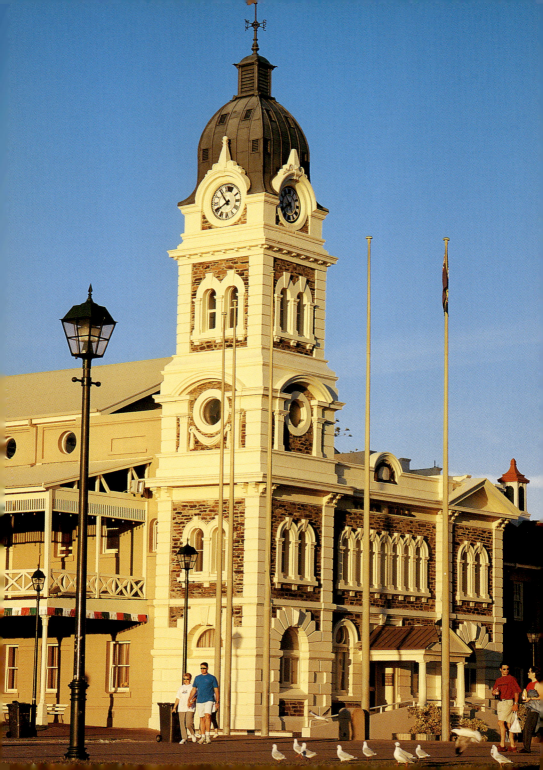

GLENELG

Glenelg is the most famous of Adelaide's wonderful beach suburbs fronting Holdfast Bay. It is the scene of the annual Proclamation Day celebrations marking the birth of South Australia. Once a seaside resort for the wealthy, the beach now hosts throngs of families on hot summer days while weekend visitors fill the shops and cafés along Jetty Road. The 1929 Bay Tram leaves Victoria Square every quarter of an hour for the ten-kilometre trip to Moseley Square at Glenelg.

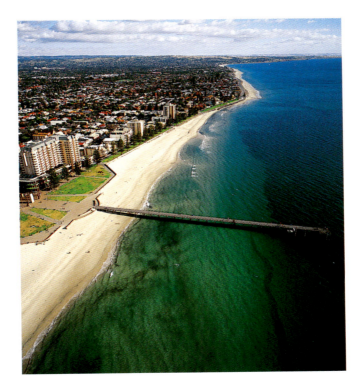

Page 20:
The Post Office on Moseley Square, Glenelg.

Left:
Glenelg Jetty stretches into Gulf St Vincent.

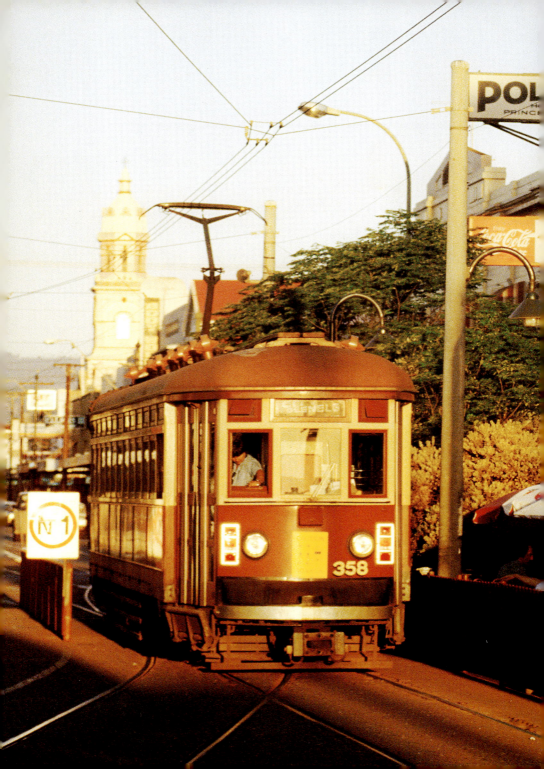

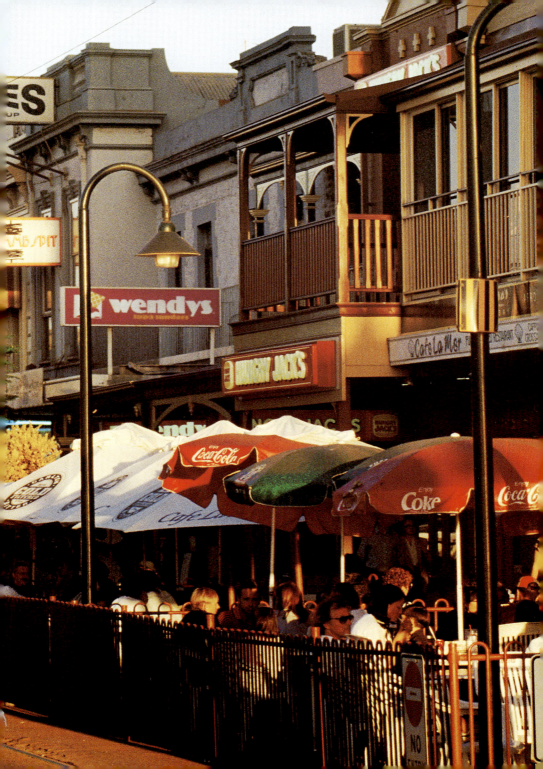

THE ADELAIDE HILLS

Quaint villages, formal gardens and natural bushland offer endless possibilities for outings to the Adelaide Hills. Lookouts at Mt Lofty and Eagle on the Hill take in magnificent panoramas of the city and Gulf St Vincent. Scenic drives wind through historic settlements, such as Bridgewater, Crafers, Stirling and Hahndorf. Colonial buildings, market gardens, restaurants and friendly pubs indulge the senses. Seasonal palettes of spring flowers and autumn leaves endow the hills with a special beauty.

Pages 22–23:
The Bay Tram heads up Jetty Road to the city.

Right:
A vintage Ford ute advertises Hillstowe Wines.

Page 25:
Hahndorf Inn offers hospitality to visitors and residents.

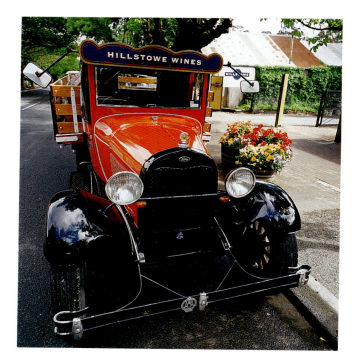

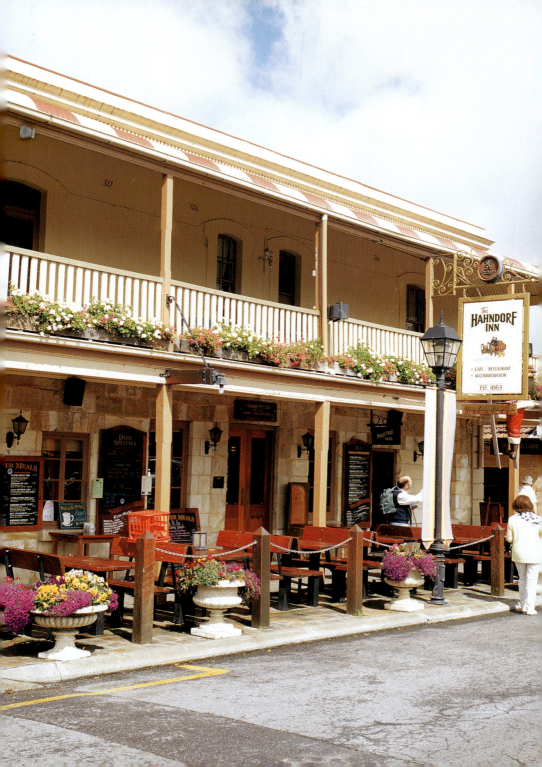

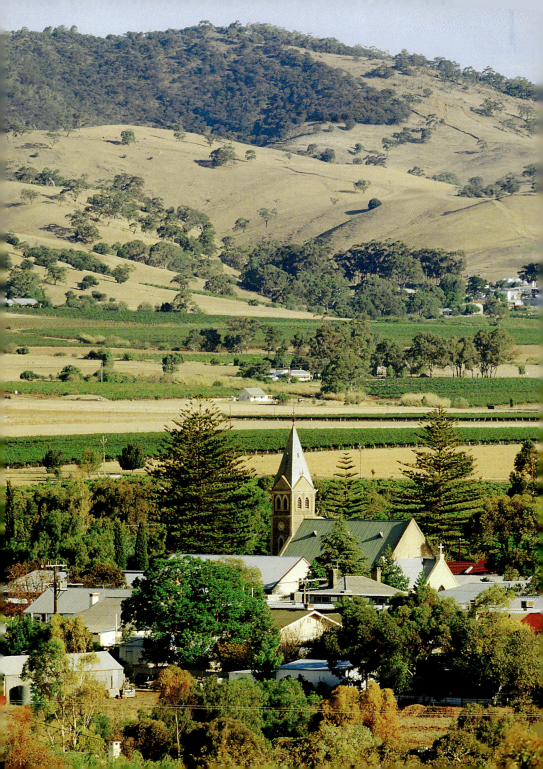

THE BAROSSA VALLEY

The Barossa Valley's prosperity and old-world charm is a legacy of its Lutheran settlers. Well-tended vineyards, orchards and olive groves spread across the undulating valley floor between the towns of Bethany, Tanunda, Lyndoch and Angaston.

Mild winters, hot summers and ideal soils produce some of Australia's finest wine grapes. Barossa hospitality extends through its grand wineries, which host tastings and tours. The biennial Vintage Festival at Tanunda is a splendid showcase of distinctive wines, good food and cultural heritage.

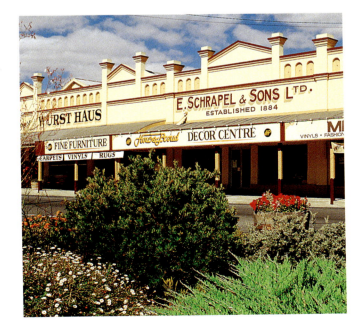

Page 26:
The peace and charm of Tanunda in the Barossa Valley.

Left:
Main street buildings in Tanunda recall earlier times.

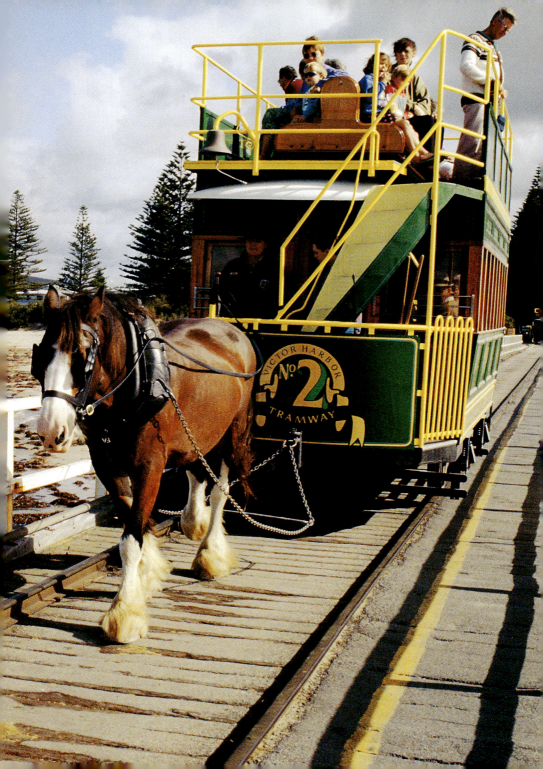

VICTOR HARBOR

Victor Harbor, originally known as Alexandra, was Governor Hindmarsh's preferred location for the state's capital. This former port and whaling town is a popular holiday destination. Visitors can cross a one-kilometre causeway by horse-drawn tram to see the Little Penguin colony on Granite Island. The steam-powered Cockle Train takes a scenic route via Port Elliot to Goolwa near the Murray River mouth. Museum displays in these coastal towns convey some of Encounter Bay's maritime history.

Page 28:
A horse-drawn tram takes visitors to Granite Island.

Left:
Victor Harbor was settled in 1837.

THE FLINDERS RANGES

The Flinders Ranges stretch 500 kilometres northwards from Spencers Gulf to the arid outback. It is an ancient landscape of rich colours and striking beauty where jagged bluffs rise above grassy plains. Steep-sided gorges carve through the ranges leaving trails of rock pools and seasonal waterholes. Mt Remarkable, Flinders Ranges and Gammon Ranges National Parks highlight the region's animal life, wildflowers and Aboriginal rock art.

Right: **Wilpena Pound in Flinders Ranges National Park is a mecca for bushwalkers.**

Page 31: **River Red Gums follow creeks through the ranges.**

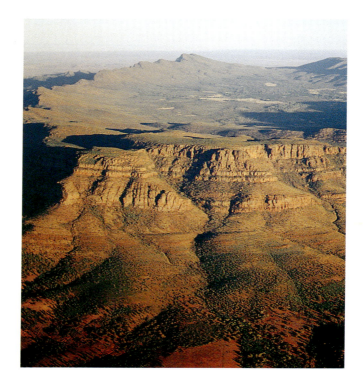

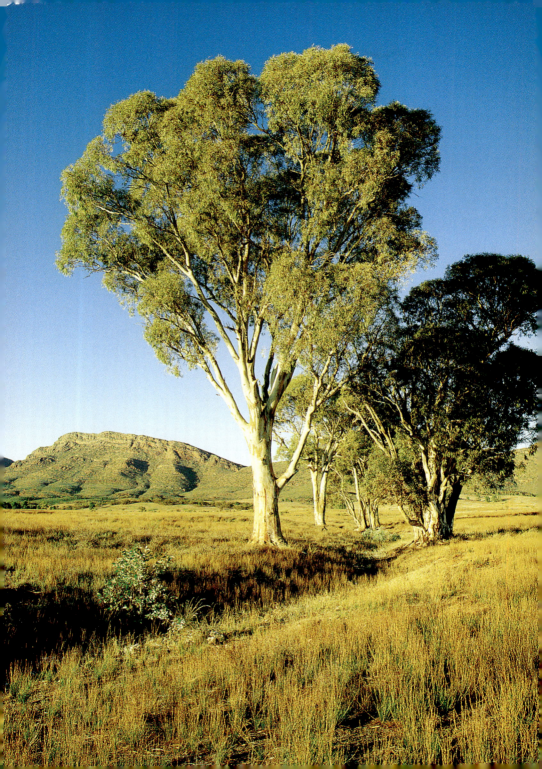

INDEX OF LOCATIONS PICTURED

Adelaide aerial views 10–11

Adelaide Festival Centre 2, 6

Adelaide University 13

Barossa Valley 26–27

Botanic Gardens 16–17

Botanic Hotel 16

Flinders Ranges National Park, Flinders Ranges 30–31

Glenelg, Adelaide 18–23

Hahndorf, Adelaide Hills 24–25

Hindley Street, Adelaide 12

Montefiore Hill, North Adelaide 32

North Terrace, Adelaide 7, 13

River Torrens 2, 4–6

Rundle Mall, Adelaide 8–9

Victor Harbor 28–29

Victoria Square, Adelaide 14–15

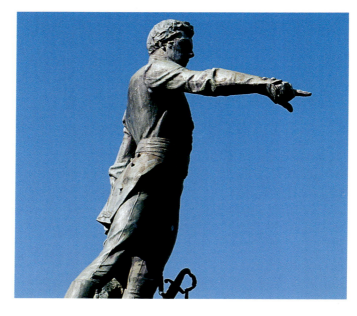

Right: "Light's Vision", a memorial to Colonel William Light, stands on Montefiore Hill, North Adelaide.